BIRDS
DRAW AND COLOR

MARTY NOBLE

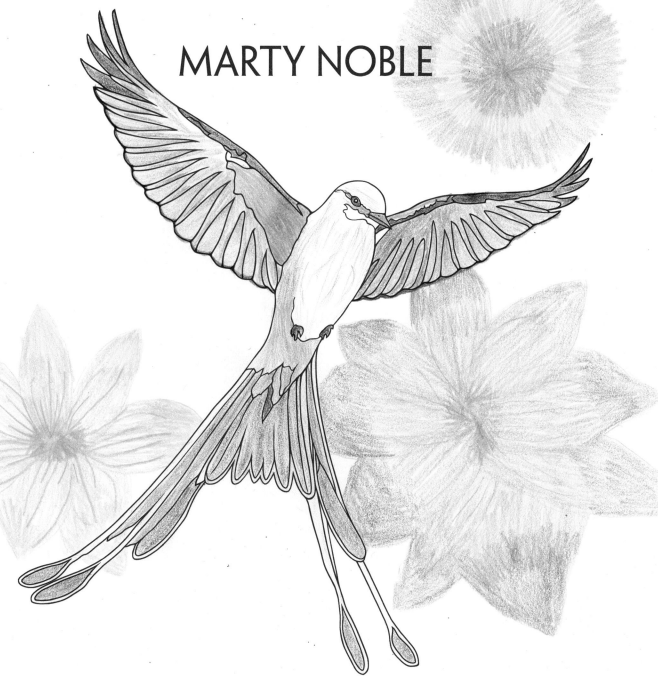

DOVER PUBLICATIONS, INC.
MINEOLA, NEW YORK

Bibliographical Note

Birds Draw and Color is a new work, first published by
Dover Publications, Inc., in 2014.

International Standard Book Number

ISBN-13: 978-0-486-79396-2
ISBN-10: 0-486-79396-6

Manufactured in the United States by Courier Corporation
79396603 2014
www.doverpublications.com

HOW TO USE THIS BOOK

This book provides you with step-by-step instructions for drawing your own beautiful birds. There is also a completed black-and-white, full page line drawing of each bird for you to use to experiment with different media and color techniques. When you are ready to begin drawing your own birds, turn to the back of the book, where you will find eloquently bordered practice pages. The practice pages are perforated for easy removal and display.

When drawing the birds, it may be helpful to imagine a line drawn through the bird from the tip of the head to the end of the tail. You can use a ruler to draw a faint line through the sample steps; this will help you determine the angle of the bird. Pay close attention to the areas where different body parts meet. There will be gently curving lines that connect head to tail, wing to body, etc. On average, the rounded or slightly oval-shaped head is usually about one-third the size of the body. But that proportion will change somewhat with different types of birds. When working on the feathers, draw the larger feather groups first, then add the smaller feathers, taking care to note the contours they follow. You can use lines to indicate changes in feather color. The body is generally oval-shaped, the wings will have a triangular shape of some kind, and the tail is shaped like a fan.

You can shade your drawing with pencil or graphite, or color it in with colored pencil, pastels, markers, or paints. Before you begin, you may wish to experiment with both soft and hard lead pencils on a piece of scrap paper to find what suits your taste.

AMERICAN AVOCET

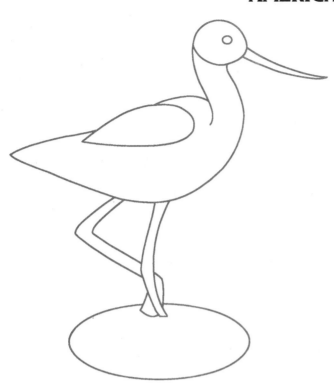

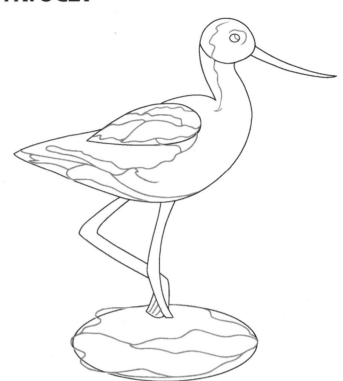

1. Draw a circular shape for the head and a long bill curved slightly up. Draw the neck and a tear-shaped body. Connect the two with a rounded curve at the breast. Draw a smaller tear shape to indicate the top of the wing. Add the legs, while carefully noting their center position on the body. Add an oval on the ground to represent water.

2. Draw an irregular line down head and neck, and add detail around the eye. Add lines to the wing to suggest feather groups, and a few more lines indicating feathers on the lower part of the wing and tail. Add lines to bottom oval to suggest ripples in the water.

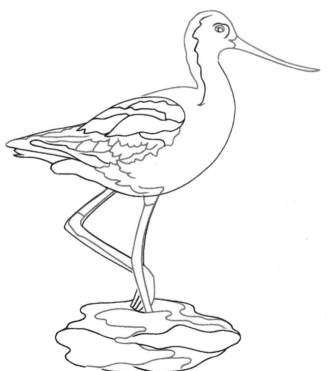

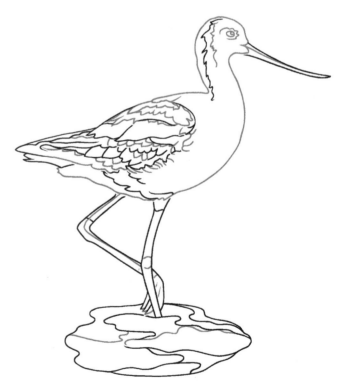

3. Refine the shape of the bill where it attaches to the head. Add more feathers under the wing. Refine the shape of the legs and tail area, and add a few more lines to the water.

4. Draw a line to separate the top and bottom of the bill, and another irregular line on the head to suggest feathers. Refine the outline of the avocet's head and body, and add more water lines.

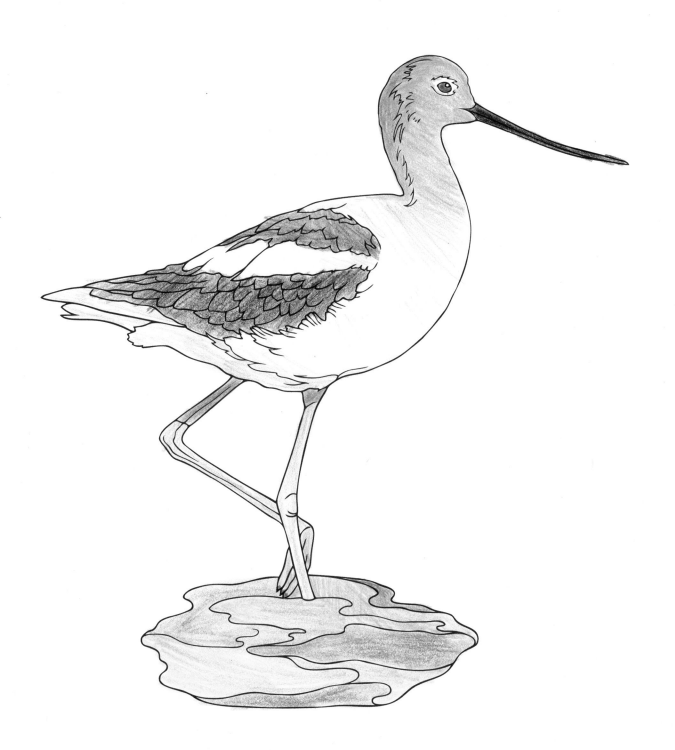

ATLANTIC PUFFIN

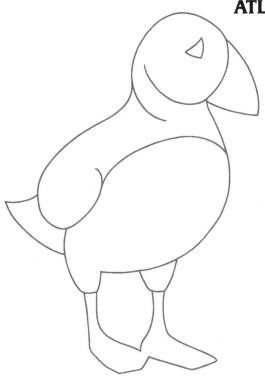

1. Draw in the body, noting the small, rounded wing and short tail, the triangular eye, and large triangular bill.

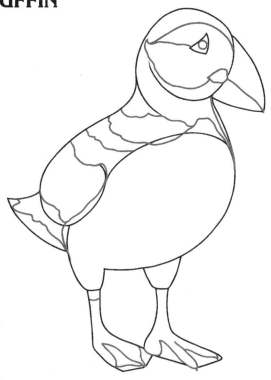

2. Add the lines on the head, and a center line on the bill. Add wavy lines following the contours of the back and coming around to the front. Refine the shape of the wing and tail and add detail to the webbed feet.

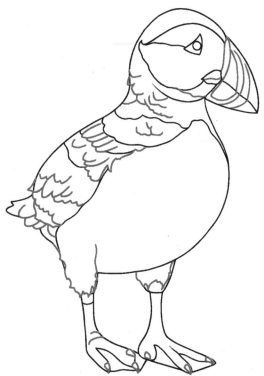

3. Add a few more lines in the area of the face and the bill. Draw in the small feathers from the neck down to the tail. Add feather detail to the legs, and more detail to the feet.

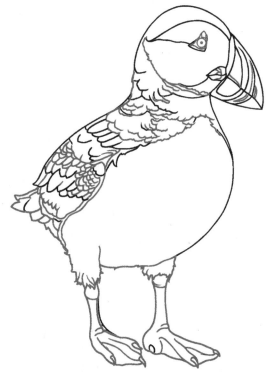

4. Draw additional feathers on the wing and body, and refine the shape of the tail. Add detail to the shape of the legs and feet, and add more detail to the bill, head, and eye. As you finish your drawing, be sure to note the distinctive features of the puffin face and bill.

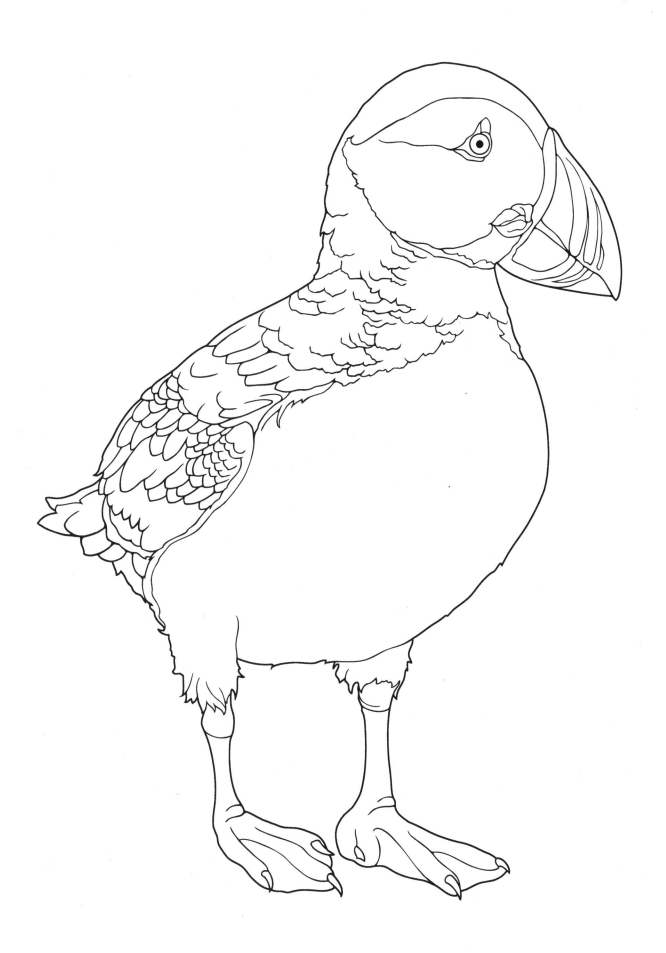

BARN OWL

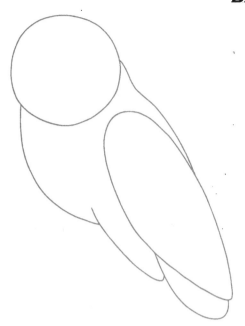

1. Start with a circle for the owl's head and draw in oval-shaped outlines for the body and wing.

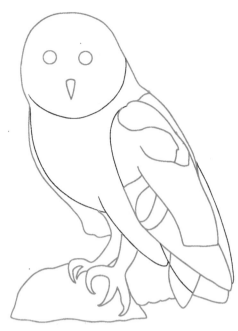

2. Add an outline for the bill and eyes. Draw some shapes on the wing to indicate feather groups. Add the legs and talons perched on a rock shape. Add the outline of the tail feathers and a suggestion of the second, less visible, wing behind the first.

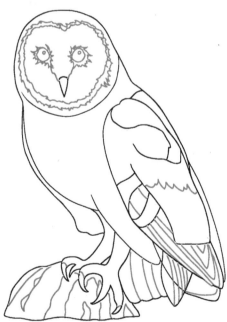

3. Add feather detail around the eyes. Add highlights to the eyes. Draw two heart-shaped, feathery outlines to the face. Add some more feather lines to the wing and tail, and another line in the middle of the wing. Add some detail to the rock.

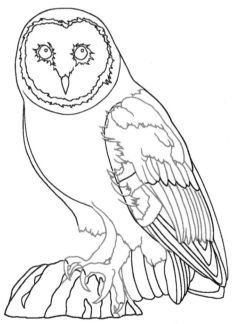

4. Draw additional feathers on the wing, and some feathery lines where the wing meets the body. Refine the shape of the legs and talons, and the tuft of feathers that extends on either side. As you finish your drawing, note that the heart shape around the face is a very defining feature of the barn owl, as are the large eyes and downward pointing bill.

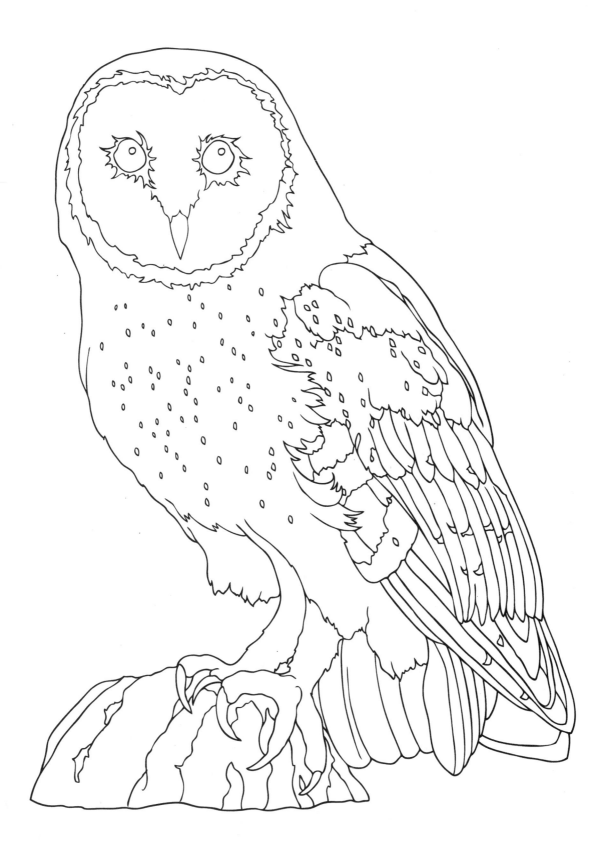

BELTED KINGFISHER

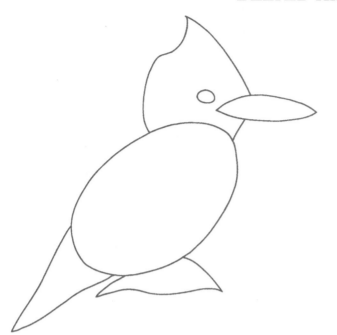

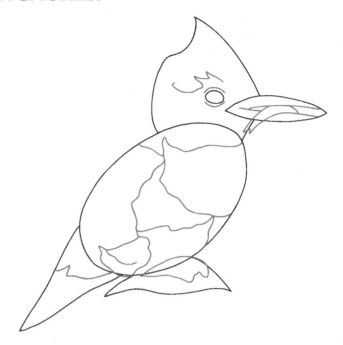

1. Draw the body, taking care to note the proportion of the head to the body. Draw in the slightly pointed head, and the large, oval-shaped bill. Add a shape underneath the bird to represent a stone perch.

2. Add lines to suggest an open beak holding a fish. Add ragged, puzzle-like shapes to the oval body, add detail to the tail, and define the feet. Add some lines around and above the eye.

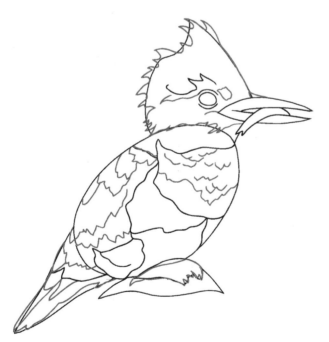

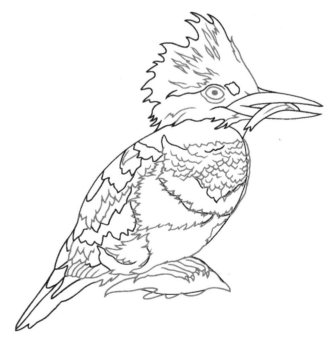

3. Draw some lines on the head to represent the bird's "spiky" head feathers. Add details on the face and in the area where the neck meets the body. Add feather detail to the chest, back, and tail, and some definition to the feet.

4. Draw additional small feathers on the chest, wing, and tail feathers. Define the feet and the stone the bird is standing on. Add feather detail to the head area and more detail to the fish.

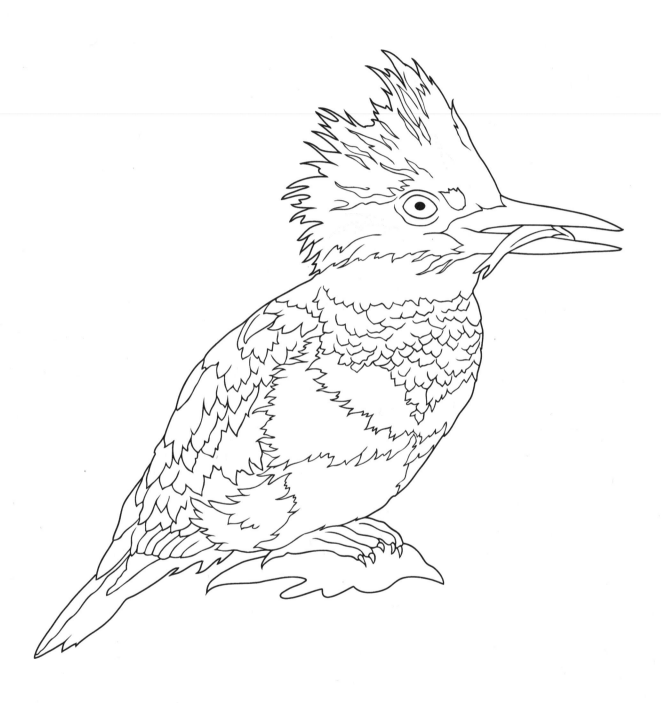

BLUEBIRD

1. Draw in the body, the tail, and two half-oval shapes for the wings. Add the bill and the eye.

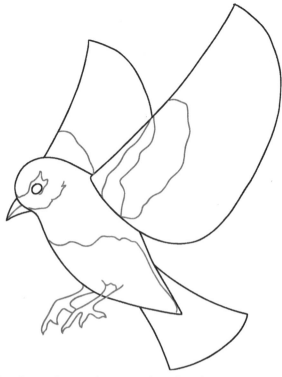

2. Draw lines above and under the eye to suggest feathers. Add some feather detail on each wing and along the chest, curving down toward the tail. Draw a line through the bill. Add the legs and feet, taking note of their position on the body.

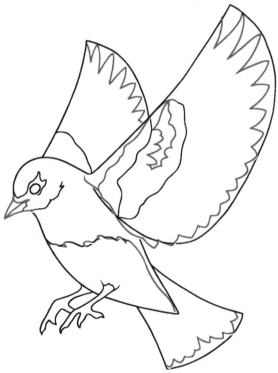

3. Refine the shape of the bill. Add more feather detail inside the wings, and feather tips to the tail.

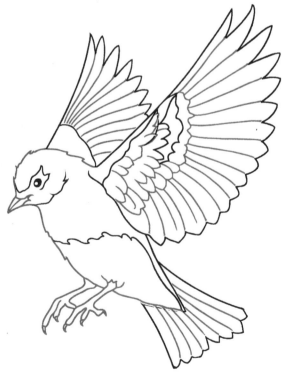

4. Draw additional feathers on the left wing and add the long lines of the extended feathers to both wings. Refine the outline of the bluebird's head and body with suggestions of more feather edges.

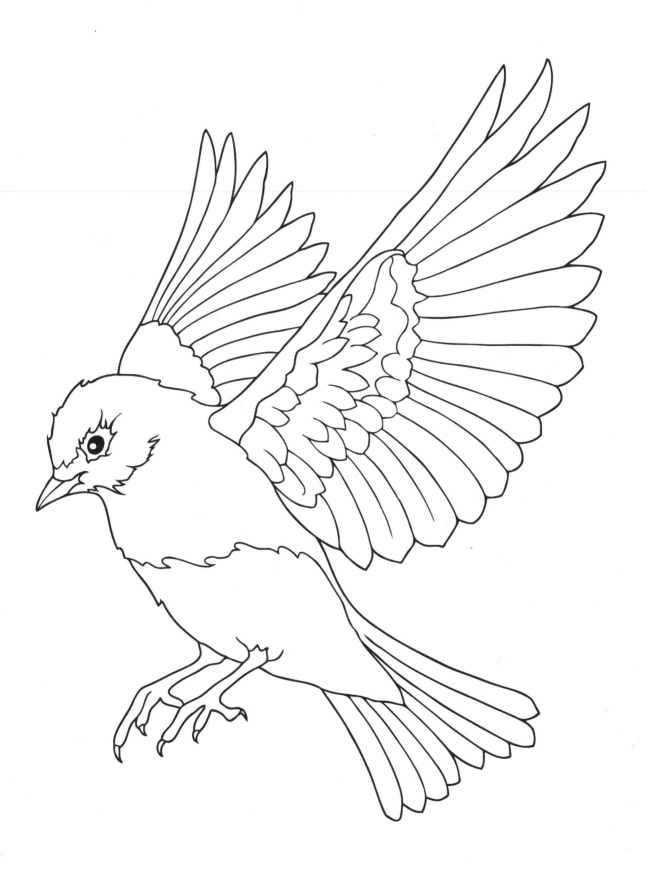

CARDINAL

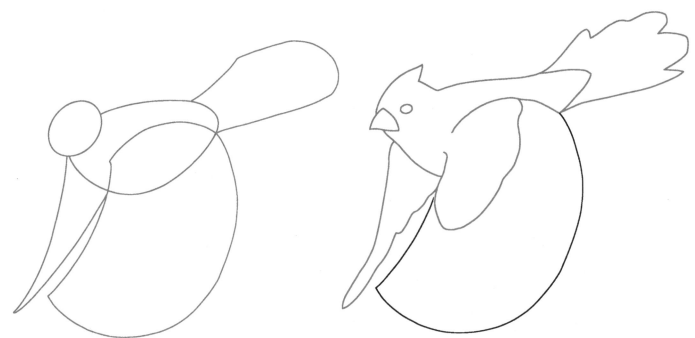

1. Draw a long oval shape for the body, a smaller oval for the head, and a fan shape for the tail. Because of the bird's angle, the wings are different in shape and size. Study the outline before adding them.

2. Add a wide triangle for the bill. Add the eye and modify the shape of the head with a point. Refine the area where the body meets the tail, and add some definition to the tail feathers. Draw a rounded line on the forward wing, and add definition to the other wing.

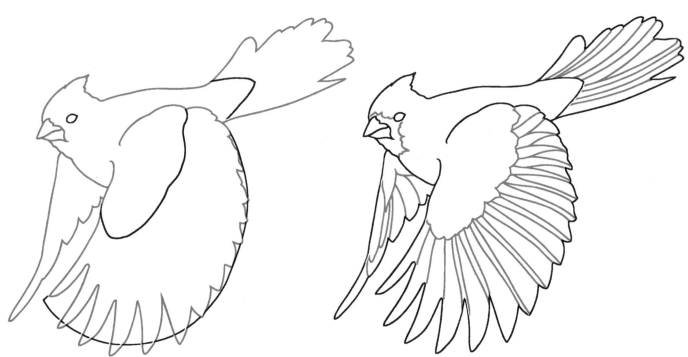

3. Refine the shape of the bill, tail, and body outline. Add feather definition to the forward wing tips.

4. Draw a feathery line on the face around the bill. Add lines to represent the long feathers on both wings, and add some definition to the upper part of the front wing. Add some defining feather lines to the tail.

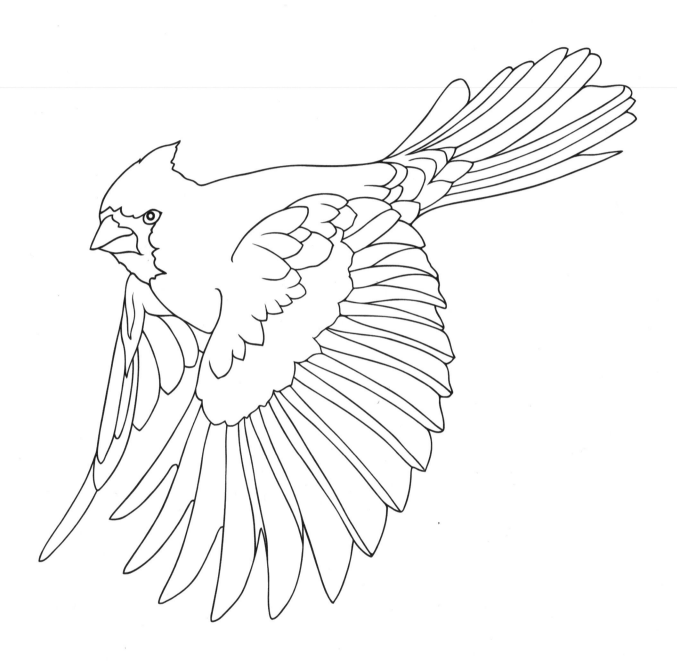

HUMMINGBIRD

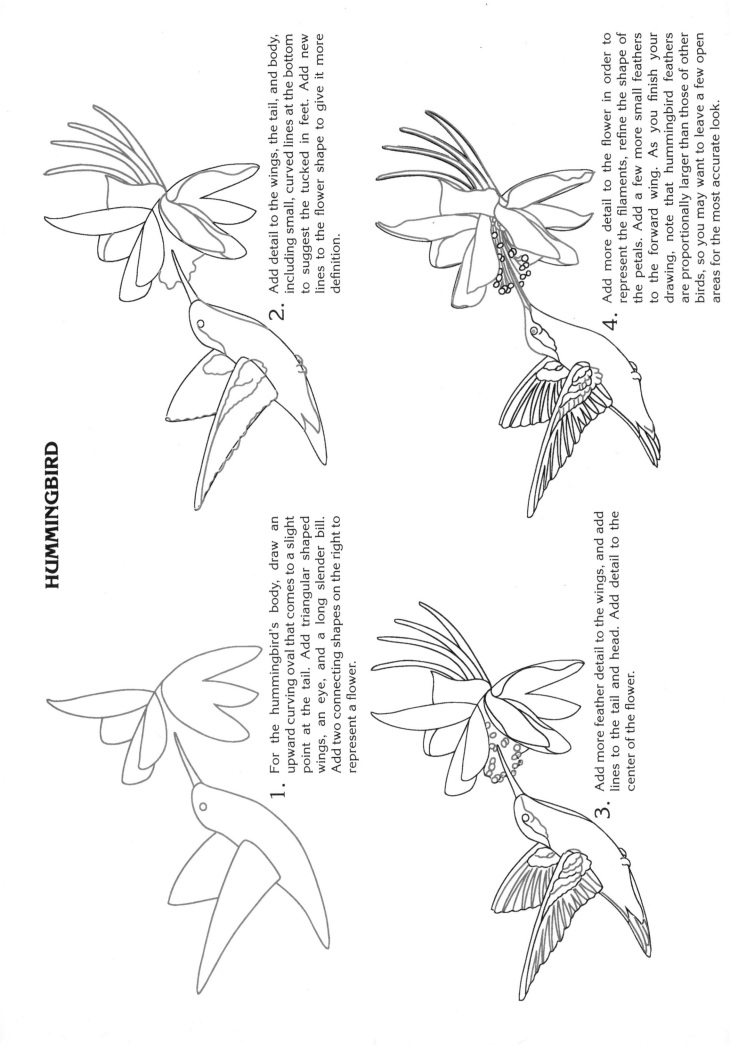

1. For the hummingbird's body, draw an upward curving oval that comes to a slight point at the tail. Add triangular shaped wings, an eye, and a long slender bill. Add two connecting shapes on the right to represent a flower.

2. Add detail to the wings, the tail, and body, including small, curved lines at the bottom to suggest the tucked in feet. Add new lines to the flower shape to give it more definition.

3. Add more feather detail to the wings, and add lines to the tail and head. Add detail to the center of the flower.

4. Add more detail to the flower in order to represent the filaments, refine the shape of the petals. Add a few more small feathers to the forward wing. As you finish your drawing, note that hummingbird feathers are proportionally larger than those of other birds, so you may want to leave a few open areas for the most accurate look.

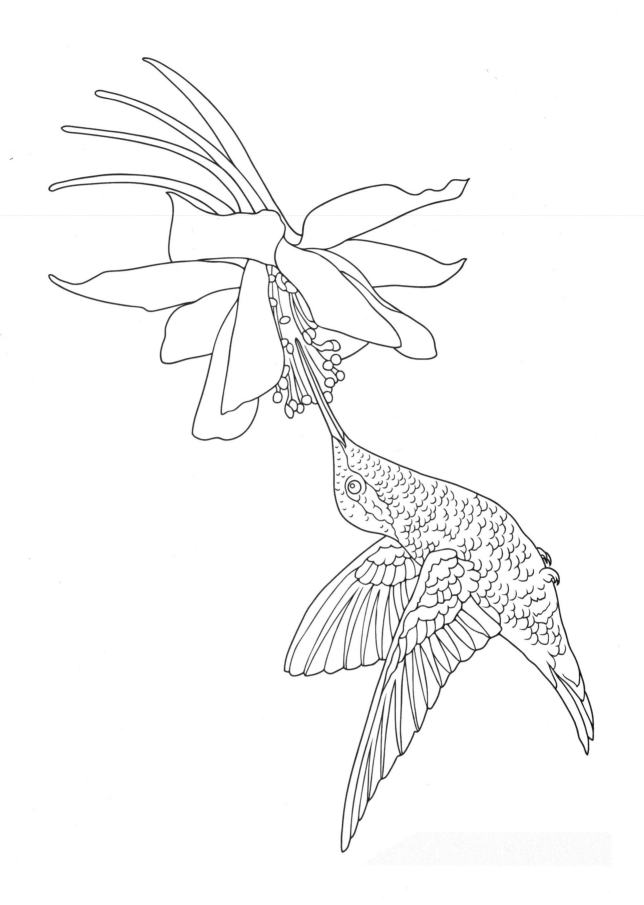

AMERICAN KESTREL

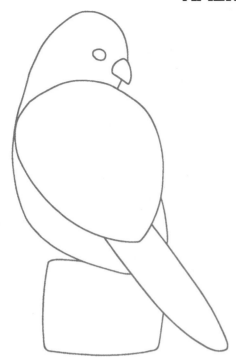

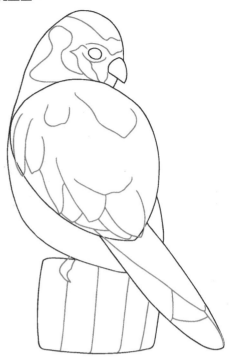

1. Draw a wide, angled tear shape for the wing. Add an elongated partial-oval for the tail, and curved lines for the head and body underneath. Draw the eye and the bill. Perch your kestrel on a post by drawing a square shape underneath him.

2. Add some large feather shapes to the wing and tail. Draw one talon hanging over the post. Add some vertical lines to the post. Draw some lines on the head and face.

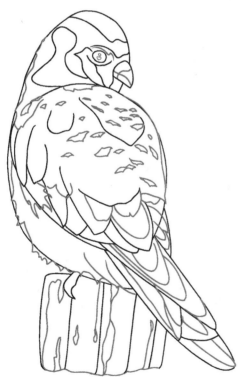

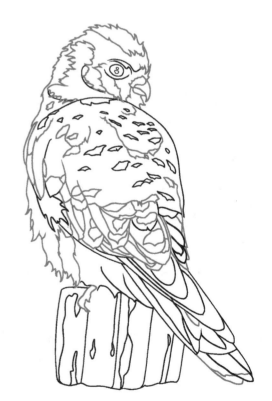

3. Add more detail to the wings. The triangular shapes indicate the color pattern. Draw more feathers in the tail, and a feathery line along the left underside of the bird. Add feather detail to the bill and eye area. Add detail to the wood post.

4. Refine the outline of the bird, and draw additional details on the wings, back, and the end of the tail. Finish detailing the face and the edge of the bill with small feathery lines, accentuating the edges.

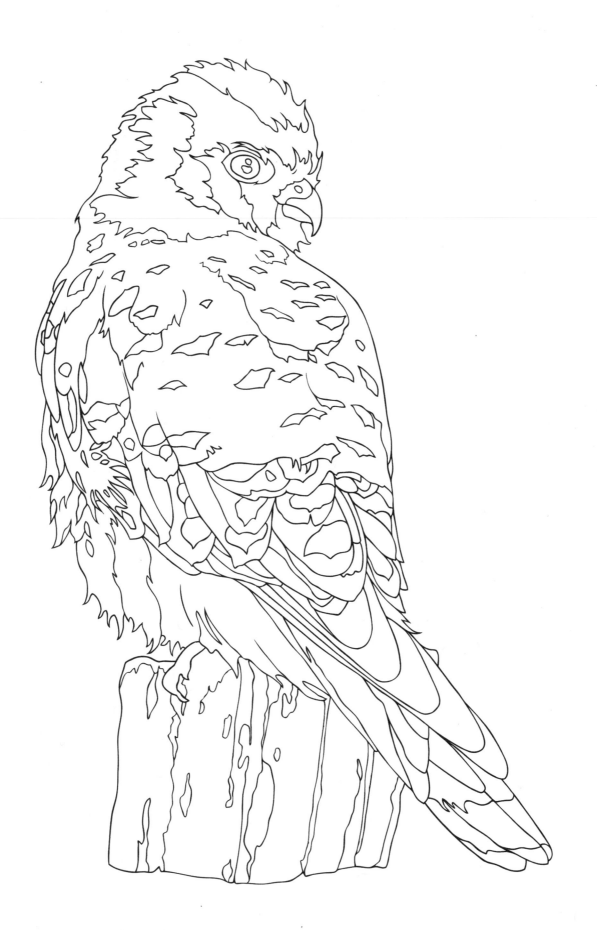

NORTHERN FLICKER

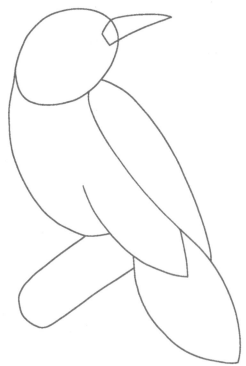

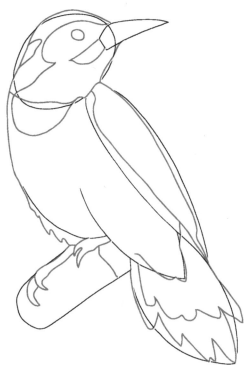

1. Draw an oval for the head and the outline for the bill. Outline the shape of the body, wing, and tail, noting that the head faces away from the body. Draw an oval shape to represent a branch for the bird to perch on.

2. Refine the shape of the bird with additional lines. Add feet, an eye, and some markings on the face. Add scalloped outlines for the tail feathers.

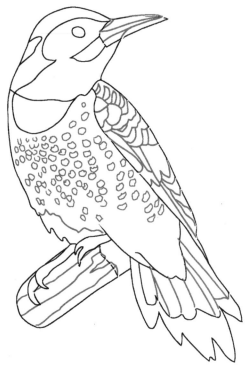

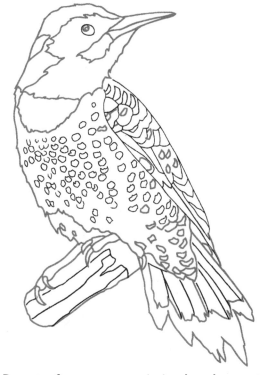

3. Add some lines to the flicker's bill. Add some feather detail to the wing, and a few lines to the tail and wood perch. Draw semi-circular shapes on the chest to represent the bird's color pattern.

4. Draw a few more semi-circular shapes to the bird's underside and the wing. Accentuate the edges of the head and body with an irregular outline. Refine the eye, feet (talons), and edges of the tail feathers.

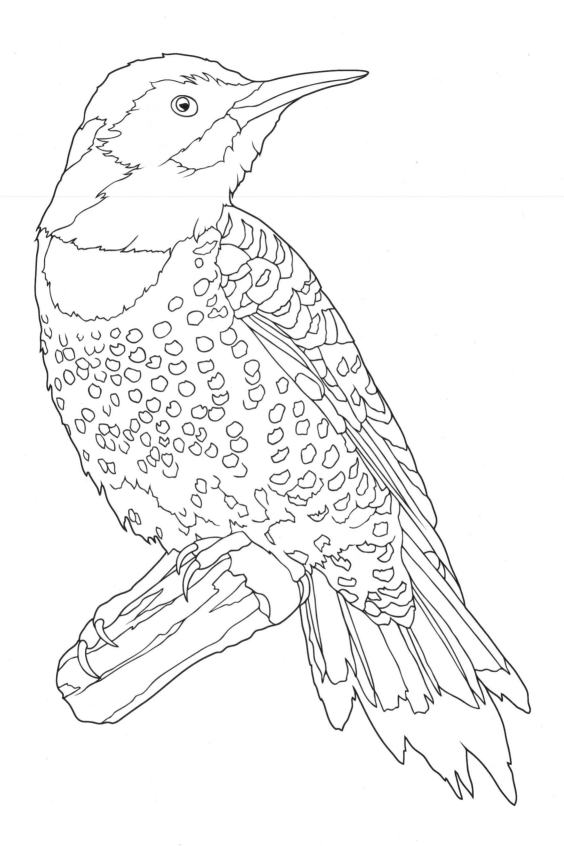

(BALTIMORE) ORIOLE

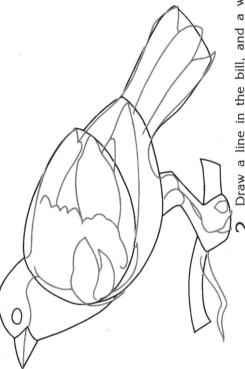

1. Start with a wide oval for the wing, and then outline the body, head, legs, and perch. Draw a diamond shaped bill, and add an eye and a rectangular shape for the tail.

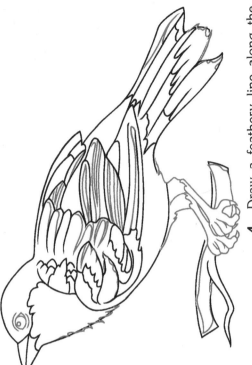

2. Draw a line in the bill, and a wavy line across the head. Add some feather shapes to the wing, and some defining lines to the tail, legs, and feet. Add a small branch to the perch.

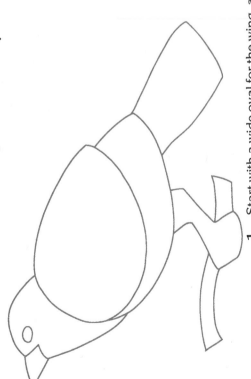

3. Draw a number of small feather lines between the bill and the wing. Add more lines to the wing and tail to indicate the longer feathers. Add additional detail to the tail, legs, and feet.

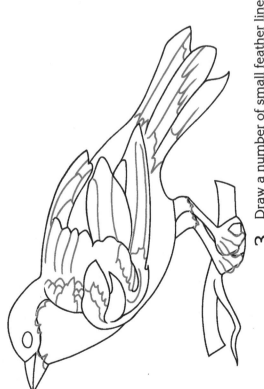

4. Draw a feathery line along the underside of the neck and add some detail to the eye area. Refine the perch, feet, and legs. Add line detail to the wing and tail feathers.

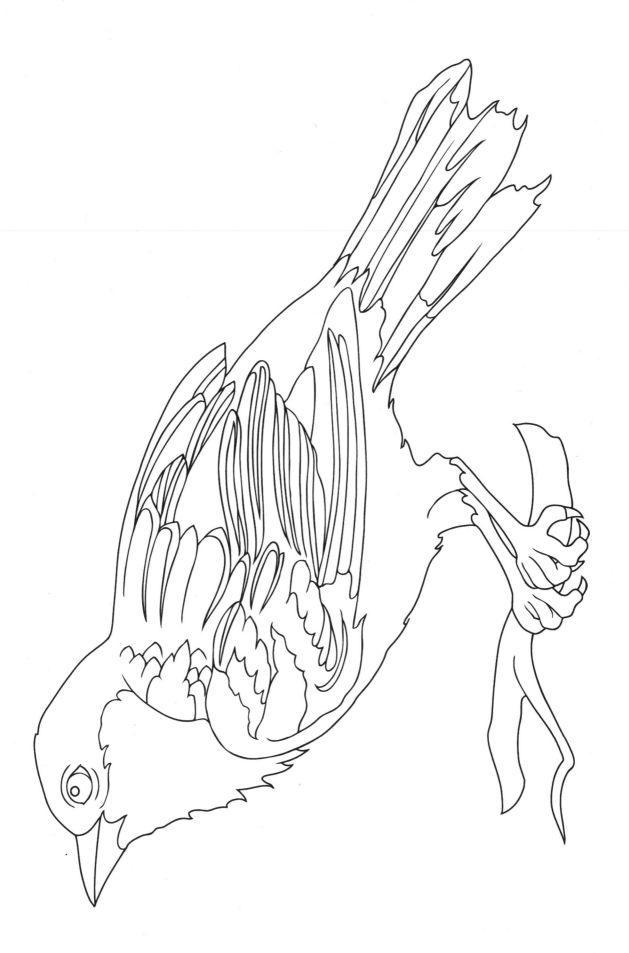

PINTAIL DUCK

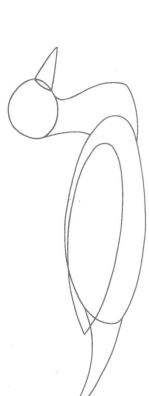

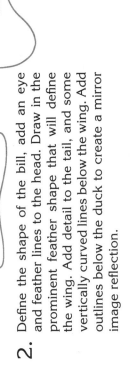

1. Draw an elongated oval for the body, and an upward tilted triangular shape for the tail. Add a smaller oval for the wing, bringing it to a point over the tail. Draw a circle for the head, and lines to connect the head and the body. Add the bill.

2. Define the shape of the bill, add an eye and feather lines to the head. Draw in the prominent feather shape that will define the wing. Add detail to the tail, and some vertically curved lines below the wing. Add outlines below the duck to create a mirror image reflection.

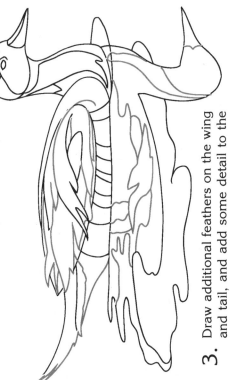

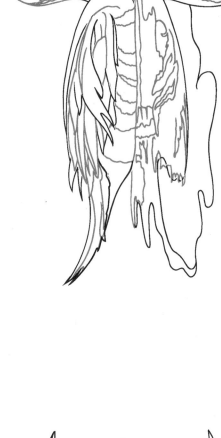

3. Draw additional feathers on the wing and tail, and add some detail to the reflection.

4. Continue adding feather detail to the wing and tail, and to the reflection. Don't be too concerned with accuracy in the reflection. Relax the outline of the head.

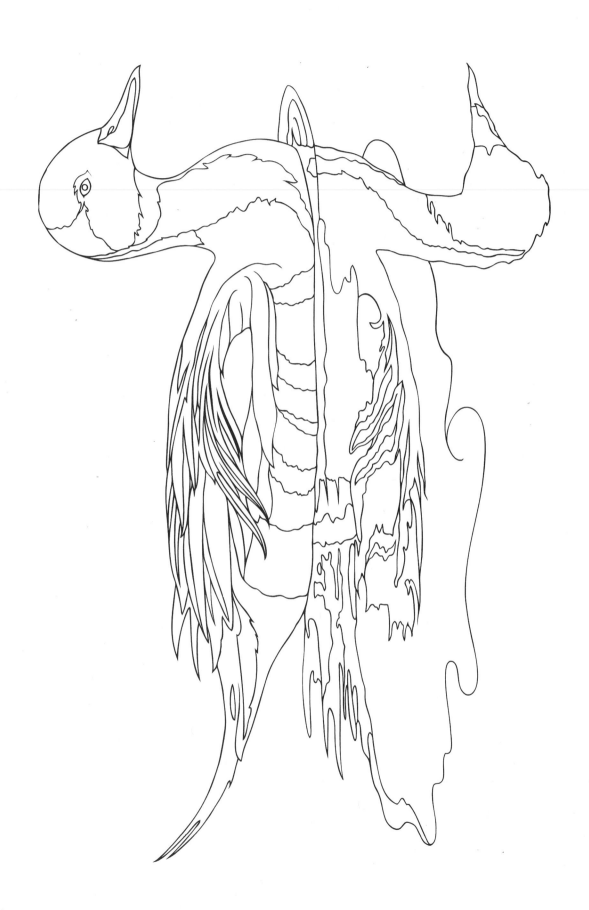

SANDHILL CRANE

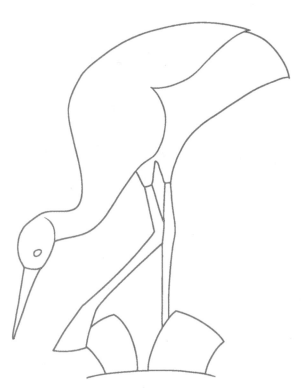

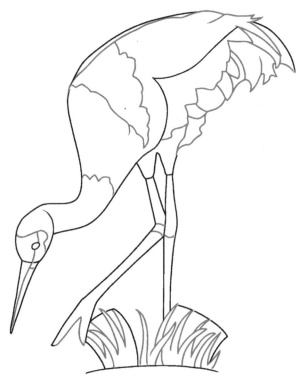

1. Draw a tilted partial-oval to create the outline of the body. It should slope upward and come to a point for the tail. Draw a small oval for the head, a long bill, and a curving neck which continues into the wing. Add long legs, and the outline for the grass.

2. Add lines to the grass to create the individual stalks. Add a wedge-shaped line on the exposed foot. Add joint lines to the legs. Draw some defining lines for the feather groups on the back and tail area. Reduce the curve of the back with another line.

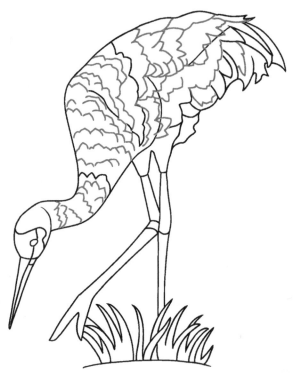

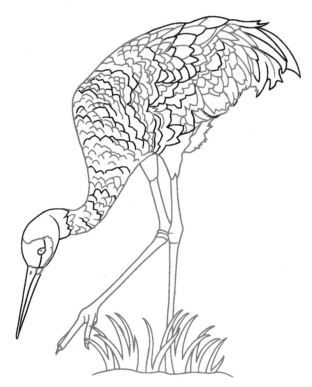

3. Add additional feathers following the contours of the body.

4. Add more feathers to the main body. Define the feet and legs, and the feather tufts on the crane's underside. Add more detail to the head and grass.

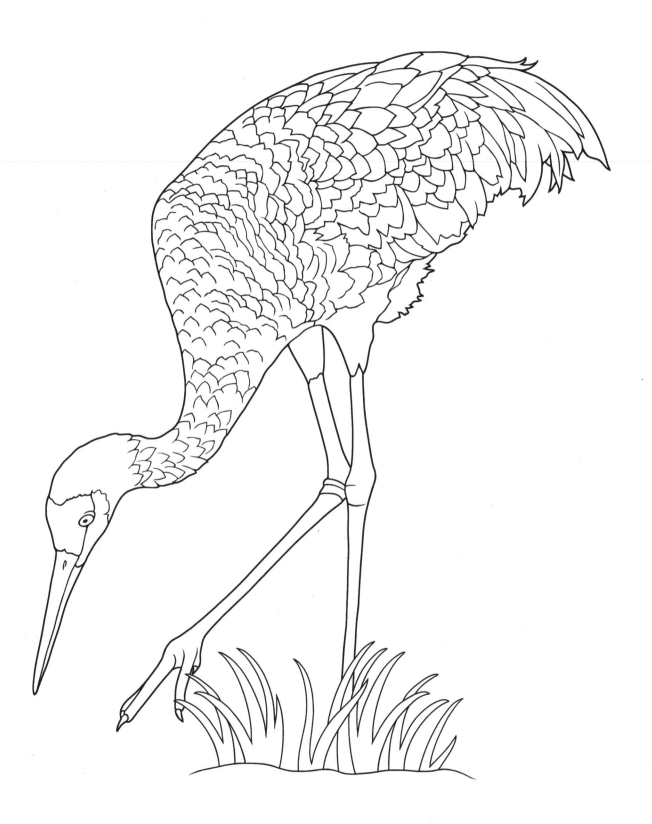

SCISSOR-TAILED FLYCATCHER

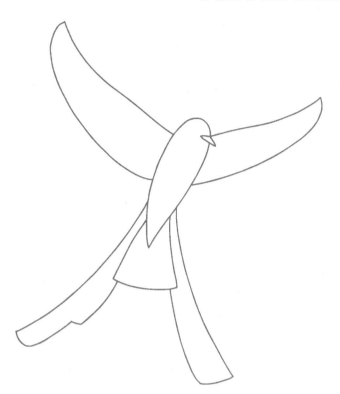

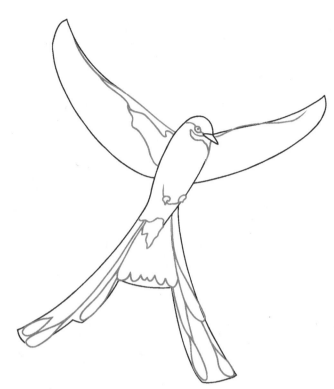

1. Draw a carrot-shaped body and add the bill. Draw two wings, slightly larger and longer than the body, and curving upward. Add a triangular shape for the main part of the tail, and two long, curving shapes for the extended tail feathers.

2. Draw the eye and the lines in the head area, as well as a few carefully placed lines in the wings. Add the feet and some feather detail in the different parts of the tail. The ends of the long tail feathers are tear-shaped.

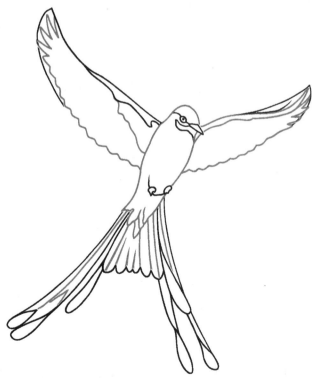

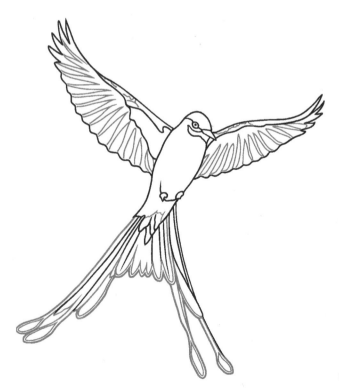

3. Refine the shape of the body and draw some pointed and scalloped feather lines at the edge of the wings. Add some feather lines to the shorter part of the tail.

4. Continue adding detail to the wings with V-shaped lines. Add some additional line work around the tail feathers.

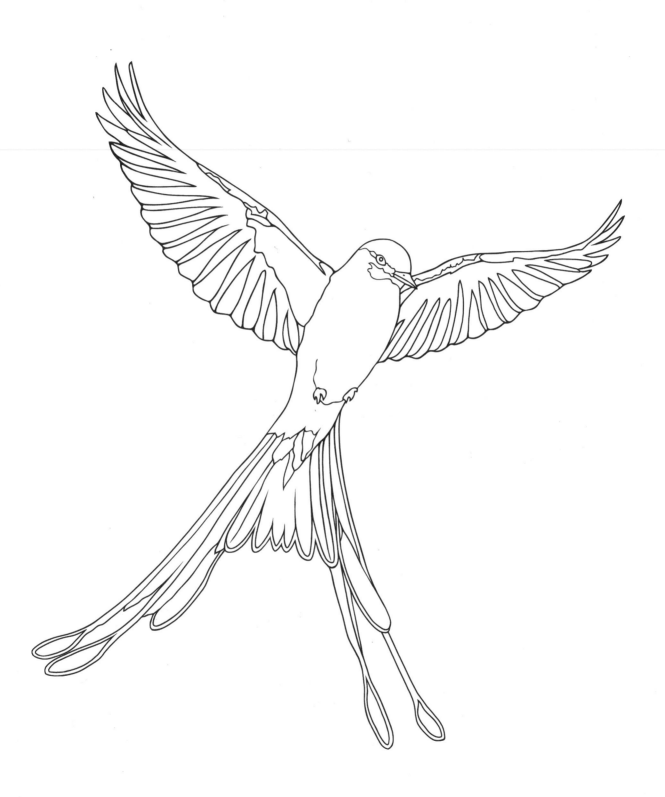

VIOLET-GREEN SWALLOW

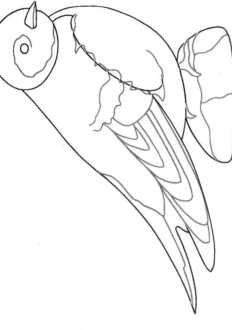

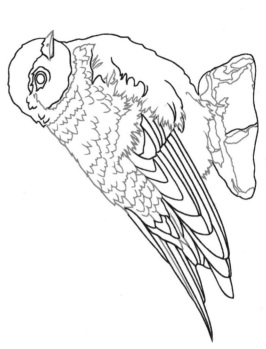

1. Draw a circle shape for the head. Add the eye and the bill. Draw a curved line for the chest, and a straighter line coming off the head, into the back and tail. Add another long shape for the lower part of the wing and a rounded shape for the rock that the swallow will perch on.

2. Draw some lines across the upper area of the wing and some longer feathers on the bottom. Add an irregular line at the inner curve of the chest and some detail in the face. Draw in the feet, and add some detail to the rock.

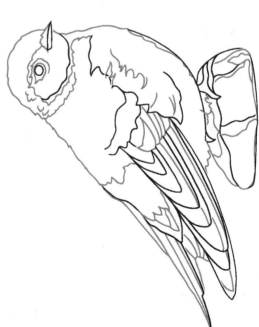

3. Add more definition to the outline of the bird, and feather detail on the head and neck. Continue drawing in wing feathers, and some smaller feathers on the lower back. Add more lines to the rock to give it dimension.

4. Add smaller feathers to the back, as well as the tufted feather detail where the chest meets the wing. Refine the bird's bill, feet, and lower body. Add more lines to the rock.

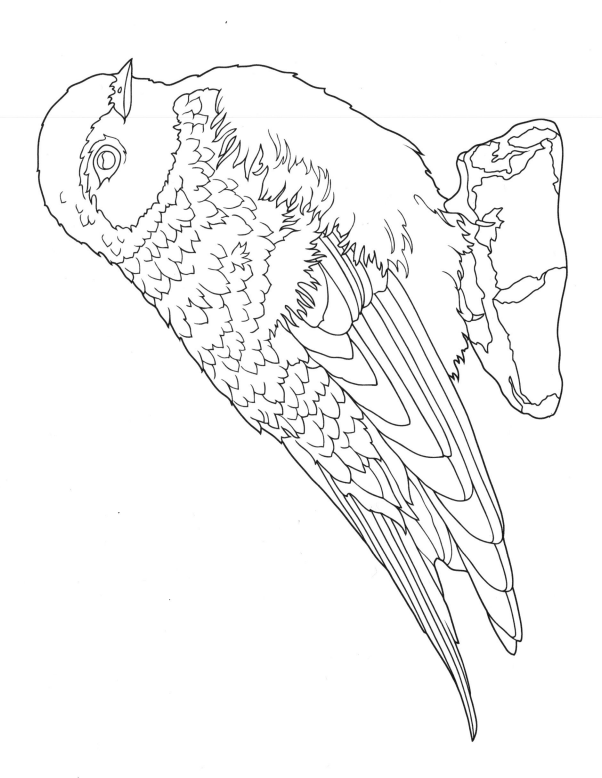

YELLOW-RUMPED WARBLER

1. Draw a vertical oval for the head and body, curving the head slightly on either side where it meets the body. Add lines for the wings and the tail. Draw the eye, and the bill.

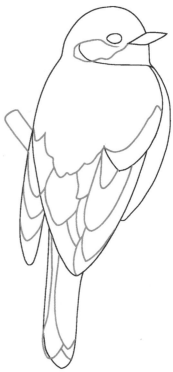

2. Add feather shapes to the wing and tail starting with a downward curving line at the back, and going into the upper part of the wing. Add a curving line starting at the bill. Add the outline for the branch the warbler is perching on.

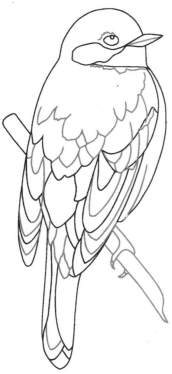

3. Add more lines to the wings. Draw more feathers along the back and upper tail, and draw the right foot wrapped around the lower part of the perch. Draw a feathery line at the neck, and over the eye. Draw another line through the bill.

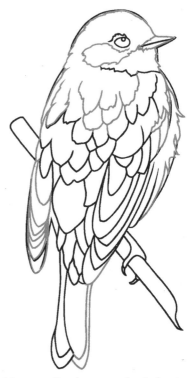

4. Add more feathers to the left wing and the back, and define the shape of the tail. Finish detailing the face and bill. Refine the outline of the bird, accentuating the feather edges.

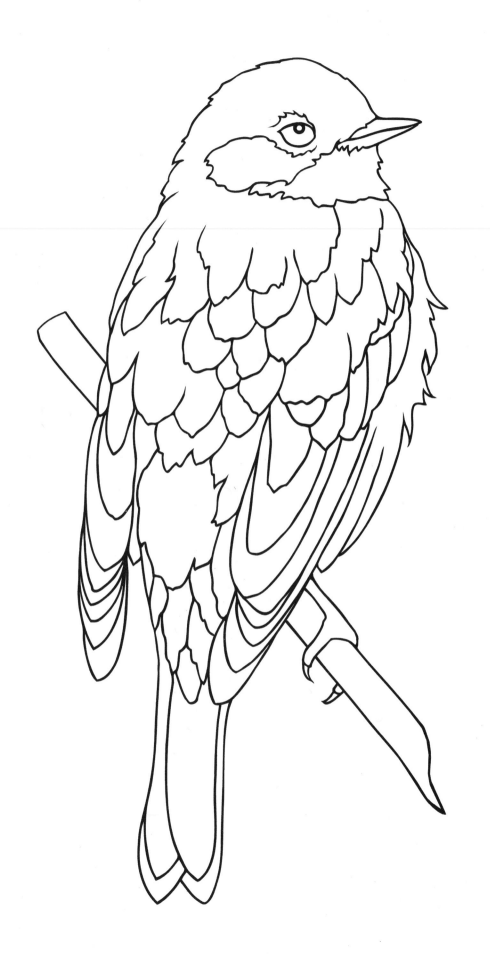